THE ART OF

INSECT
ILLUSTRATION

AND THREADS OF

ENTOMOLOGICAL HISTORY

CURATED BY
GEORGE E. BALL

DECEMBER 2004 TO MARCH 2005
BRUCE PEEL SPECIAL COLLECTIONS LIBRARY
UNIVERSITY OF ALBERTA • EDMONTON • CANADA

George E. Ball is Emeritus Curator of the E.H. Strickland
Entomological Museum at the Department of Biological
Sciences, University of Alberta.

Cover image: detail from Plate IX, *A natural history
of English insects* by Eleazar Albin.

Permission to reproduce images has been generously
provided by the following publishers:
Page 22 from *Systema naturae* by Carl von Linné
© The Natural History Museum, London.
Pages 40 and 42 from *Micrographia* by Robert Hooke
© Science Heritage, Ltd.

Catalogue designed by Marvin Harder

ISBN 1-55195-117-7

Published by The University of Alberta Libraries
Copyright © University of Alberta Libraries
Edmonton, 2005

TABLE OF CONTENTS

LIST OF ILLUSTRATIONS

DR RONALD B. MADGE

FOREWORD

The Scientific Revolution of the sixteenth and seventeenth centuries was made possible by the wide-scale distribution of printed books containing authoritative texts and accurate illustrations. Gutenberg's invention revolutionized book production, while the discovery of linear perspective by European artists in Renaissance Italy made possible the precise, geometric representation of three-dimensional objects. The invention of the microscope in the seventeeth century opened new realms for scientific investigation. Collectively, these developments transformed the study of natural history, and nowhere more so than in entomological systematics and the study of insect morphology. As entomological knowledge advanced, it generated, and was sustained by, an outpouring of publications with increasingly more accurate and sophisticated illustrations. The mechanical arts of illustration and printing were the midwives of scientific progress, and left a legacy of books of both scientific significance and great aesthetic beauty. This exhibition aims to explore the interrelationship between the science of entomology and the art of illustration by highlighting some of that legacy. The exhibition and accompanying catalogue were, in large part, made possible by the generosity of Dr Ronald B. Madge of Calgary. It is therefore our great pleasure to dedicate them to him, in appreciation of his support for our entomology collection.

While completing three degrees in entomology (BSc & PhD, University of Alberta; MS, University of Illinois), Dr Madge spent his summers with Canada's Department of Agriculture, working with insect surveys in southern Canada, Alaska, and at Lake Hazen at the north end of Ellesmere Island in the Canadian high Arctic. After completing his doctoral dissertation on the classification of the coleopteran genus *Lebia*, under the supervision of Dr George E. Ball, and a post-doctoral fellowship at the Natural History Museum in London, Dr Madge was employed from 1965 until his retirement in 1992 at the insect identification and taxonomic research division of the Commonwealth Institute of Entomology, part of the Commonwealth Agriculture Bureaux (now CAB International).

Working in London's Natural History Museum, Dr Madge was responsible for identifying beetles sent from government agriculture and forestry laboratories and universities throughout the British Commonwealth. Working with the Museum's extensive library made a lasting impression on him: "Its richness in old books let one ferret out answers to questions like the publication dates of names, and to compile catalogues of type species. Occasionally, one would stumble serendipitously across a clue to one problem while searching for something else. The Museum's library, and the other wonderful libraries that I had access to in London, have influenced my fondness for books."

Since his retirement and return to Canada, Dr Madge has continued his interest in the classification of his favourite group, the carrion beetles, as well as his determination to help his alma mater strengthen its holdings of entomology's classical works. Thanks to his generous financial support over the past decade, the Library has added many early, illustrated, antiquarian titles to its outstanding collection in the field of entomology.

Dr Merrill Distad - *Associate Director of Libraries*

INTRODUCTION

A part of the more general field of zoology, entomology is defined broadly as the study of insects. But "insect" is used in two senses. The first is a general one, including all terrestrial-based arthropods: hexapods (dragonflies, grasshoppers, beetles, moths and butterflies, etc.), arachnids (spiders, mites, and ticks), and myriapods (centipedes and millipedes). The second is specific to just the hexapods. Hexapods and spiders form the subject of the following presentation, because they are the groups that historically have received and continue to receive most of the attention of entomologists.

The time period encompassed by this brief, eclectic historical review (limited necessarily by available publishing space and principally to the literature available in the University of Alberta Library) extends from the seventeenth century to the end of the nineteenth century, with brief reference to entomological publications of the sixteenth and twentieth centuries. The arrangement is principally chronological, but because some volumes available are copies (facsimile re-issues or reprintings) of the original versions, these copies are discussed in the sequence indicated by publication date of their original counterparts.

A prominent feature of most of the volumes noted is the illustrations that accompany and illuminate the written text. Improved quality of illustration generally parallels the improving knowledge of insects from the Renaissance into the twentieth century. This parallel development is the subject at the base of this exhibition. The illustrations were chosen both to display artistry and to encompass as many different insect groups as possible, including most major Orders (Odonata, dragonflies; Orthoptera, grasshoppers; Dictyoptera, cockroaches and praying mantids; Thysanoptera, thrips; Phthiraptera, lice; Hemiptera, aphids; Coleoptera, beetles; Hymenoptera, ants and wasps; Diptera, two-wing flies; Siphonaptera, fleas; Lepidoptera, butterflies and moths; and Araneae, spiders).

Entomology, in its endeavour to develop and expand knowledge of insects, now draws directly on and contributes to many areas of science, such as morphology, histology, systematics, ecology, embryology, physiology, parasitology, pathology, cytology, genetics, biochemistry, evolution, and biogeography. In its time of earliest development, insect study focused on establishing knowledge that would come more recently under the headings of diversity and insect morphology (body form and structure). Diversity can further be delineated into systematics (naming, description, classification, relationships) and ecology (way of life and environmental relationships).

THE NATURE OF
ZOOLOGICAL ILLUSTRATION

Development of entomological iconography must be considered in the more general context of zoological illustration, since entomology is a part of zoology. According to Knight (1977), for centuries animal pictures were chiefly important for their symbolic value, in association with a text reminiscent of *Aesop's Fables*, that reminded a reader how to live morally. Later, they depicted the infinite wisdom and fecundity of the Creator. Finally, animal illustrations became a convenient and then essential means of displaying the characteristics of an animal so that its species could be identified and organ systems understood. In making zoological illustrations, therefore, an artist (or illustrator) was not simply making a portrait of a single animal (such as a pet dog or a prize bull) for its own sake. Further, zoological illustrations are accompanied by and complement the descriptive text, which gives them a context of a name and geographical place. But pictures of most animals are not convincing illustrations unless the artist has carefully looked at the animal itself, and has some idea of structure and function of the observable parts.

PRODUCTION AND
REPRODUCTION OF IMAGES

Development of insect illustration, as noted by Knight (1977), follows that of zoological illustration in general. It began with marking outlines on mammal bones or rock faces, and on the walls of buildings as civilizations developed. Later still, drawings were made on paper, using ink. This allowed for the distribution of illustrations from where they were drawn to wherever they might be carried. Further, copies could be made, though sequential copying over time led generally to the loss of detail, and thus to a decline both in the quality of an illustration and in its value as a representation of reality.

This problem was overcome with the advent of printing in fifteenth-century Western Europe, using movable wooden blocks of type. An illustration could be carved on a block of wood, inked like letter type, and then used to produce multiple identical copies. The resulting print could be very good, depending upon the artist, but it was difficult to produce fine lines and other details. This limitation of wood as a material was mostly overcome toward the end of the eighteenth century with the development of wood engraving. The end grain surface of boxwood was used, which gave a dense, hard, and uniform surface, allowing for a much greater amount of detail to come through.

A major advance in production of accurate images came with the development of engraving on the surface of copper plates by Joris Hoefnagel, who in 1592 published 326 figures of insects that had been produced by his son, Jacob. However, this process had two disadvantages: first, it was very expensive, and second, it was not possible to include engravings on the same page with the printed text.

Lithography, developed in 1798 by Alois Senefelder, proved to be cheaper than engraving, and had the added advantage of permitting almost continuous grading of textural or colour tones, a result that could be only approximated with engraving (Dance 1978). However, lithography was not used extensively until the second half of the nineteenth century. By the early twentieth century, photolithography assumed a major role in production of illustrations. Along with these improvements in printing, paper quality increased, and colour inks were developed. These vastly improved printing techniques contributed significantly to the dissemination of entomological knowledge, as a whole.

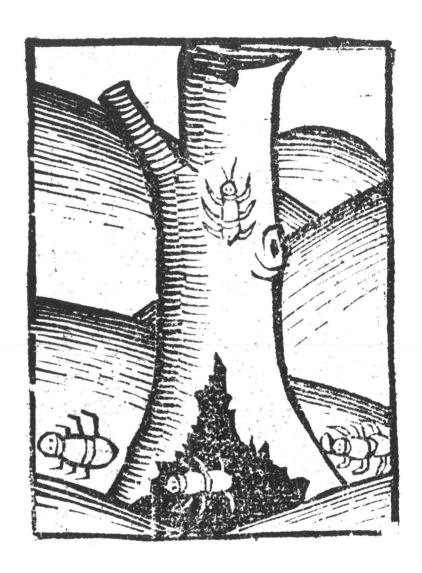

Image [n.p.] from *Ortus sanitatis*

ENTOMOLOGICAL
BEGINNINGS

Humanity's interest in insects has been evident through many forms of representation, including in artistic, religious, and early scientific publications. In pre-historic times, artisans depicted insects through bone carvings or rock-face drawings. In early Egyptian culture, scarab beetles were an important component of the religion of the time, and are prominent in paintings from that period. And lists of names of particular insects (mainly pest grasshoppers, but also mantids and dragonflies) appear on cuneiform tablets in the Sumerian language, dating to nearly 2000 BCE. Aristotle (384-322 BCE) provided a hierarchical classification of insects and much accurate information about them in his general treatment of animals (Morge 1973). The Bible contains numerous references to insects of one kind or another. The Roman author, Pliny (23-79 CE), in the eleventh book of his *Historia naturalis*, treats insects, but his observations were chiefly copies of the works of Aristotle, derived from intermediary sources. See Leach (1830), Smith, et al. (1973), and Kevan (1985) for a more detailed account of early entomological history.

The principal characteristic of biological publication, from the fall of Rome to medieval times, was the absence of reporting original observation. A major source used by subsequent authors was the *Physiologus*, a compilation made in the second century CE, from

Page 303 from Aldrovandi's *De animalibus insectis libri septem*

which were derived over the following fourteen centuries various volumes about plants ("herbals"), and about animals ("bestiaries"). These books were illustrated with hand-copied figures, and included treatments of various insect species. With the advent of printing, illustrations were produced by woodcuts. For the most part, the images seem to have been produced from memory by the artist, rather than from close observation of actual specimens. An example from the early Renaissance is shown by an insect illustration from the extensively illustrated *Ortus sanitatis* (1517). The figure is purportedly of ants ("Formica" as declared in the text), emerging from their nest at the base of a tree. Note that the insect images are imprecise in both form and scale.

The *Ortus sanitatis* was an herbal-cum-pharmacopeia, treating plants and animals of medical importance, and had been copied from earlier medieval encyclopedias. The images of animals (including insects) were markedly generalized and inaccurate; in contrast, the numerous illustrations of plants in this volume, and in the medieval herbals, were sufficiently well-executed so that they are identifiable to species.

As a field of scientific endeavour, entomology did not exist before publication of the first Renaissance-age book devoted to insects, although knowledge of insects prior to the Renaissance was extensive. The focus on insects as living entities in their own right came in 1602, with publication of the first volume that featured insects, *De animalibus insectis libri septem*, by Ulisse Aldrovandi (1522-1605), a professor, philosopher, and physician, in Bologna, Italy. Basically an extensive (if not exhaustive) encyclopedic compilation of information from the medieval literature, some new observations by Aldrovandi were included in this volume of more than 700 pages. This general treatment, which may be regarded as the first textbook of entomology, was organized according to the principles established by

pite,collo,& alis,minutulis pun-
ctis nigris denſè conſperſis; cor-
poris magnitudine ferè ſecun-
dum æquat Cerambycem:rari-
ùs conſpicitur;in ædibus vivit &
lignis aridis. Sexto cineraſcenti
caput valde exiguum,oculi albi-
duli, cornua longiuſcula, articu-
lata,candeſcentibus maculis di-
ſtincta:elytris,imo toto ferè cor-
pore,varius eſt,in ædibus
item verſatur, ſed an eti-
am in lignis habitet,igno-
ro. Septimum ex Ruſſia
ab Edoardo Elmero alla-
tum vidi,toto corpore in-
fuſcatum,juncturas habuit

in cornubus globoſas,ſeptem vel octo;facile ex forma cognoſcitur. Ab hoc
octavus magnitudine & forma parum abludit,niſi quod capite, ſcapulis & alis
ſubcæruleis præditus videtur.

 Nonum miſit ad Pennium Ioachimus Camerarius(de li-
teraria repub.optime cum primis meritus) cui alæ pedeſ-
que arenoſi erant coloris; caput cornua venterque ſubni-
gricabant : cornubus repandis videbatur, ex pluribus
verticillis noduliſve compoſitis, quæ in utramvis partem
nictu citiùs verſabat. In plantis (& potiſſimum Ci-
thyſo) repitat. **Hujus generis eſſe** puto Scarabeum,
quem Ioannes du Choul. (lib.de varia quercus hiſtoria,
cap. 26.)ita deſcribit : *Degit in quercu animal de ſcarabe-*
orum tribu (quantum conjectura ducimur) *colore nigrican-*
te,proceris cruribus, geminos capite gerens aculeos, modicè
inflexos : quibus acerrimè ſtringit adverſantia. Hanc be-
ſtiolam fabri lignarij quercus dolantes, in ipſis viſceribus
vivam invenere. Ruſtici Lugdunenſes Thurro *nominant.*
In laquearibus felicius diutiuſque vivit, ſeque hypocauſta
colentibus levi cum ſtrepitu prodiens conſpiciendum ſubinde
præbet. Eundem vel illi ſimilem quendam piæ memoriæ
Geſnerus Epiſt. Lib. 3.ab anu pleuritin paſſa dejectum
fuiſſe teſtatur in hæc verba : Per aluum (inquit) à potione
ex Oxymelite noſtro cum decocto fænugræci exhibita,

prodijt vetulæ pleuritide laboranti,
ſcarabei genus nigrum, longis pedibus,
longis item cornubus flexibilibus articu-
latiſque,rudi plenum pure, vivum ; lon-
gitudine duorum articulorum erant digi-
ti. Decimus totus ex nigro purpurans,
os forcipatum habet. Vndecimus ubi-
que atreſcit. Duodecimo cornua minus
articulata, caput ſcapulæque cyaneæ,re-
liquum corpus totum ſpadicem videtur.Horum omnium
in iconibus, utcunque cornua aliàs directa, aliàs curua-
ta cernitis (explanationis gratiâ;tamen plerunque non
niſi

Page 151 from Moffett's Insectorum sive minimorum animalium theatrum

Aristotle (circa 350 BCE). Figures in Aldrovandi's publication are numerous, and are rather crude woodcuts. Body form depicted in the accompanying plate is generalized, and the patterns of the wing veins are imprecise. Nonetheless, the fact that the veins are shown at all indicates that illustrations were drawn from examination of specimens, and not simply from memory.

Another pioneering entomologist, an English "doctor of physick," was Thomas Moffett (1553-1604), purported father of "Little Miss Muffet," who lived at the same time as Aldrovandi but worked independently of him. He produced another treatment of insects, *Insectorum sive minimorum animalium theatrum*, dedicated to Queen Elizabeth I. Although written around 1580, the book, with text in Latin, was not published until 1634. An English translation was published by Edward Topsell, in 1658, as part of his extensive but uncritical encyclopedic work on animals.

Based principally on English insects, Moffett's *Insectorum* is profusely illustrated, but the figures are mostly too small to show adequate detail. Like Aldrovandi's tome, the figures are coarse woodcuts that are closely associated with the text, thus enabling ready comparison of verbal description and image. The images of the beetles shown, and most of the others in this volume, are useless for species-level identification. But they, and the associated text, give a reasonable idea of the genus of the images; for the time, that was good enough.

For examination of small creatures, the most momentous event of the seventeenth century was the invention of the compound microscope by a Dutch maker of spectacles, Zacharias Jansen, between 1591 and 1609 (Locy 1925). This invention led unintentionally to two paths of entomological endeavour. On the first, a researcher focused on larger whole organisms and their way of life, for which a compound microscope was not required (though a single powerful

lens was useful if not essential), and is designated as "insect diversity." The other path, for which a microscope is required, featured the study of details of insect structure and smaller organisms, and is designated as "insect microscopy and anatomy."

INSECT DIVERSITY

In the first half of the eighteenth century, well-illustrated entomological publications focused on ecological aspects of insects, especially life histories. Most of these volumes were financed by wealthy patrons, whose names were prominently featured in effusive dedications. Such patronage was a reflection of a stylish interest in natural history by various members of the Western European wealthy and entitled classes. Most volumes treated selected insects, or insects grouped by geography (English insects; Jamaican insects; insects of Madeira and Barbados; insects of Surinam).

In 1705, a German woman, Maria Sibylla Merian (1647-1717), published at her own expense a series of hand-coloured engraved plates illustrating insects in her two-volume *De generatione et metamorphosibus insectorum Surinamensium*, described by Dance "as the most magnificent work on insects so far produced"(1978: 50). It was the first large illustrated work concerning exotic insects, with their stages of development portrayed. The University of Alberta Library does not have these volumes, but an idea of Merian's skill may be gained from the figures of arachnids (especially the tarantula, at top), from the 1976 *Butterflies, beetles and other insects*.

224

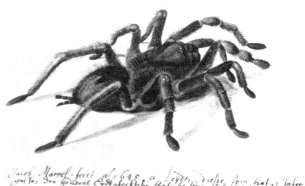

225

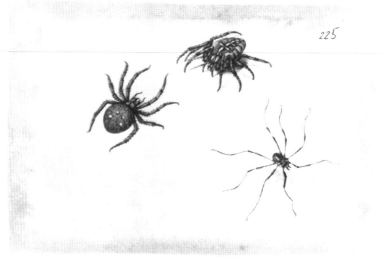

Plate 317/88 from Merian's *Butterflies, beetles and other insects*

Merian was a remarkably determined woman of some means; her father had been a successful and presumably well-paid (and thus well off), engraver of biological subjects. At the age of 51, and accompanied by two daughters, she undertook the first entomological expedition (to Surinam, between 1699-1701) for the sole purpose of forming a collection and learning about tropical insects. During the course of her visit, she worked out life histories of the insect species that she encountered. Dance notes,

> She was a highly original artist, and her portrayals of living insects and other animals were imbued with a charm, a minuteness of observation and an artistic sensibility that had not previously been seen in a natural history book. Directly or indirectly, she may have exerted a long-term influence on the work of subsequent zoological artists and the authors of books in which animal illustrations appear (1978: 51).

Working along a line similar to Merian was Eleazar Albin (1713-1759), a teacher of drawing and painting in London with a passion for natural history, particularly birds and insects (Lisney 1960). In 1724, Albin published *A natural history of English insects*. The text, organized by species, describes with elegant clarity and simplicity the life history of each species treated (principally moths and butterflies), with reference to an adjacent copper-engraved and hand-coloured plate illustrating the various life forms. Plate IX from that work shows a hawk moth adult (upper surface, fig. d; under surface, fig. e); the other stages of the life history (eggs, f; different colour forms of larvae, a and b; and c, pupa); the food plant (13), with larvae thereon; and the environment in which the food plant grows (a pond margin). An adult ichneumon wasp parasite (g) that emerged from one of the larvae is depicted.

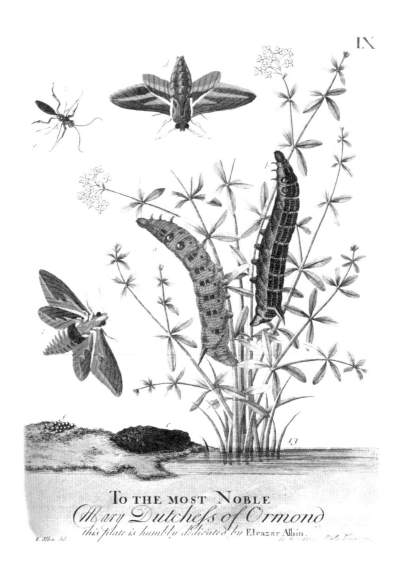

IX

To the most Noble
Mary Dutchefs of Ormond
this plate is humbly dedicated by Eleazar Albin.

E. Albin del.

Plate IX from Albin's *A natural history of English insects*

The plate, then, is more than a set of pretty pictures in isolation, because the latter are related to one another through development (the insect life stages), or by dependence on the plant (the larvae) or on the hawk moth larvae (the wasp) for sustenance, with all ultimately dependent upon the general environment, as represented by the pond in which the plant is growing. Thus, through context, the images gain a level of generality they would not have in isolation.

The printing toward the bottom of the engraved plate is the dedication to one of the patrons who financed the publication. Each plate is similarly dedicated: 100 plates, and 100 patrons! The importance of such patronage cannot be overemphasized, for it supported what was a very expensive, high-quality publication, and thus the development and dissemination of accurate, detailed knowledge of natural history.

Albin refers to the species simply with the vernacular "the Elephant" as was customary at that time. It is now known informally as the Elephant Hawk Moth, and formally as *Deilephila elpenor* Linné.

R.-A.F. de Réaumur (1683-1757) was a man of wealth, and with one of the most wide-ranging minds of the eighteenth century, devoted his life to various studies in biology, including the process of digestion. He was well known for his invention of "Réaumur's porcelain" and for a thermometric scale, which he devised. His self-described working principles were the following: that studies made from pure curiosity could result in useful discoveries; to trust not what one hears, but to look for oneself; to write clearly; and that drawings should be made of external as well as internal organs. Réaumur's work gave inspiration to successors, as did his sympathetic personality (Taylor 1963; Tuxen 1973).

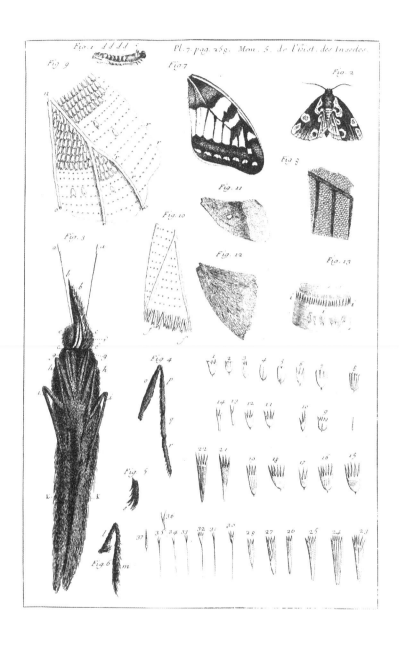

Plate 7 from Réaumur's *Mémoires pour servir à l'histoire des insectes*

To gain an adequate understanding of insects, Réaumur stated that it was necessary to study and describe the life history and "industries" of as many insects as possible. The purpose of his six-volume survey of the insect world, *Mémoires pour servir à l'histoire des insectes* (much of it based on Réaumur's personal observations), was to stimulate interest in these creatures. The first volume, *Sur les chenilles et sur les papillons*, treated the Lepidoptera (butterflies and moths). For Réaumur, "life history" required knowledge of the detailed structure of an organism, gained in part through use of a compound microscope. An example of this attention to detail is provided with the accompanying plate, showing body form of an adult butterfly (Fig. 3), with scales in place; the upper surface of a complete forewing (Fig. 7); details of wing veins, from the underside, with scales in position (Figs. 8-10); and a number of isolated scales (Nos. 1-23), showing variation in form and size.

A.J. Rösel von Rosenhof's (1705-1759) four-volume series, *De natuurlyke historie der insecten* (1764-1768), was a posthumous printing and reissue of parts originally published separately as *Insecten-Belustigung* (1746-1761). A painter and engraver without formal training as a naturalist, Rösel von Rosenhof developed an indefatigable interest in insects. He was a very careful observer, drawing and engraving the images himself, although the figures were hand-coloured by others. The images are notable for their lifelike appearance: for example, the grasshopper plate shows the animal both resting and in flight. Only a person who had watched living grasshoppers and then conducted a minute examination of specimens could make such pictures. On the moth plate, Figs. 1-7 illustrate the life stages of one species, including a single egg (Fig. 7) and the adult as it emerges from its cocoon (Fig. 4). Figs. a and b are male and female, respectively, of another species of moth. As stated by Tuxen (1973), the hand colouring is exceptional.

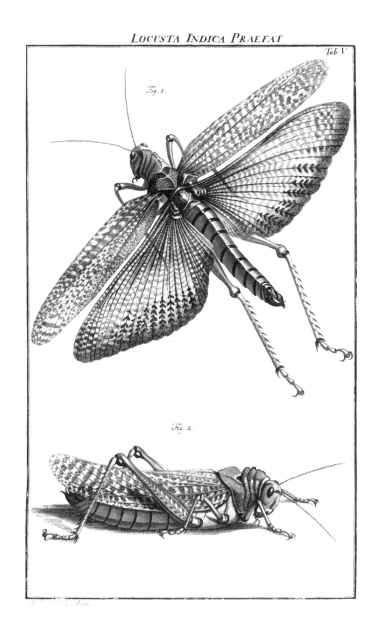

Tab. V from Rösel von Rosenhof's *De natuurlyke historie der insecten*

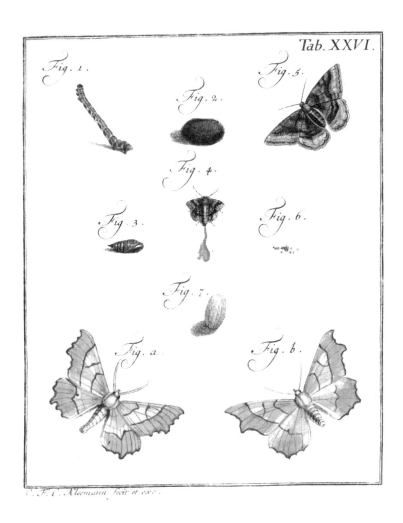

Tab. XXVI from Rösel von Rosenhof's *De natuurlyke historie der insecten*

Raj. inſ. 87. *n.* 9. Scarabæus ▽ ſubrotundus e cæru-
leo viridi ſplendente undique tinctus.
Ræſ. app. 1. *p.* 195. *f.* 31.
Habitat in Europæ *lacubus, curſitans ſupra aquam velo-
ciſſime; in* America. *Kalm.*

Scara- 15. D. ovalis convexus ater læviſſimus, antennis filifor-
bæoides. mibus triarticulatis.
Ræſ. inſ. 2. *aqv.* 1. *t.* 4.
Habitat in Europæ *aquis.*
Magnitudo Scarabæi.

186. CARABUS. *Antennæ* ſetaceæ.
Thorax obcordatus apice trunca-
tus, marginatus.
Elytra marginata.

* *Majores.*

coria- 1. C. apterus ater opacus, elytris punctis intricatis ſubru-
ceus. goſis.
Habitat in Germania. *P. Forſkål.*
Inter maximos Europæos numerandus. Totus *ater, læ-
vis.* Elytra *absque ſulcis ex punctis confuſis excavatis
confluentibus confertis.* Antennæ *corpore breviores.*

granula- 2. C. apterus, elytris longitudinaliter punctatis.
tus. *Fn. ſvec.* 511. Carabus ater, elytris convexe punctatis.
ſtriatisque.
β. Carabus niger, elytris ſubvireſcentibus convexe puncta-
tis ſtriatisque. *Fn. ſvec.* 512.
γ. Carabus purpuraſcenti-niger, elytris convexe punctatis
ſtriatisque. *Fn. ſvec.* 513.
Raj. inſ. 96. *n.* 2. Cerambyx purpurea punctata.
Liſt. mut. t. 18. *f.* 4. *Hoffn. inſ.* 2. *t.* 3.
Habitat in Lignis *putridis.*

leucoph- 3. C. apterus, elytris lævibus: ſtriis obſoletis octonis.
thalmus. *Fn. ſvec.* 515. Carabus ater, elytro ſingulo ſtriis octo.
Habitat in Europa.
*Thorax, ratione magnitudinis inſecti, minor quam in re-
liquis.*

4. C.

Carabi *Larvæ ſæpe intra Ligna putrida, muſcos, terram &c. degunt; Volatilia vero
inſectorum imprimis Larvarum Leones ſunt, curſu feſtinantes.*

Page 413 from Linné's *Systema naturae*

One of the most important publications of the eighteenth century was the tenth edition of the *Systema naturae*, written in Latin by the Swedish university professor, Carl von Linné (1707-1778). The volume is not illustrated, but it is so fundamental to development of the study of animal diversity that it must be included in a review such as this. Scientifically, this work was noted for a clear, consistent system of classification of all animals. The known insects were grouped in a single class, "Insecta," and within this class, in seven "Orders," depending upon their structural features (principally differences in wings). Those included in each Order were arranged in sequentially numbered genera, and the members of each genus were grouped into species, which were also numbered.

The accompanying image indicates the structure of the system: genus 186, *Carabus* (a member of the Order Coleoptera), the name followed by a brief description. Three species follow (an additional twenty or so on the following pages), each described, with "Habitat." Note the literature references for the second species. But in addition to the description, each species was designated by a single word—the *nomen triviale*—at the left margin of the page (*coriaceus, granulatus,* and *leucophthalmus*). A complete name of each species was thus designated by two words, the generic name and the *nomen triviale*, in the system known as binominal nomenclature. This volume was the first in which binominal nomenclature was used consistently for the entire animal kingdom. Previously, species naming had been mostly inconsistent and confusing, polynominal and cumbersome. Following Linné, the binominal system was adopted widely, and became standard for naming animal species (for plants, binominal nomenclature had been used by Linné beginning in 1753). Although Linné's classification was changed over the years as a result of new knowledge, the binominal system of nomenclature at the species level is unchanged.

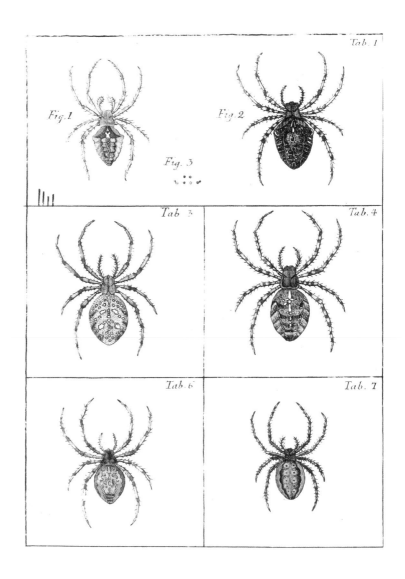

Plate I from Clerck's *Svenska spindlar* (detail)

Another major contribution of Linné was the goal that he set for himself and for future biologists of learning, describing, and classifying all species inhabiting the earth. With that goal, and the use of consistent and clear systems of nomenclature and classification, biological systematics developed and blossomed as a distinct field of endeavour. This was timely, for specimens of numerous life forms previously unknown to the Western Europeans were accumulating as a result of the collecting activities of shipboard naturalists and others in the course of government-sponsored exploration. These expeditions were designed to locate additional sources of wealth that could be exploited in lands, which themselves could be claimed in the name of one European monarch or another. Also, much exotic biological material was obtained through itinerant naturalists who paid for their travels by sale of their specimens to government institutions or private collectors.

A Swedish friend and associate of Linné, Carl A. Clerck (1710-1765), chose to concentrate his biological interests on spiders when time away from his official duties as a tax collector in Stockholm became available. He had no formal academic training, but evidently was inspired by public lectures that he heard Linné present. In 1757 (a year before publication of the tenth edition of the *Systema* established the date for valid animal names), Clerck published his *Svenska spindlar* (Spiders of Sweden). This work pioneered spider classification. Because he used binominal nomenclature consistently therein, Clerck's publication was subsequently recognized as the starting date for valid spider names. The publication is also noteworthy because of the fine engraved and hand-coloured illustrations. Additionally, many similar images appear on a single plate, with identical arrangement of all those included. This presentation makes easy the comparisons that must be made to identify an unknown spider.

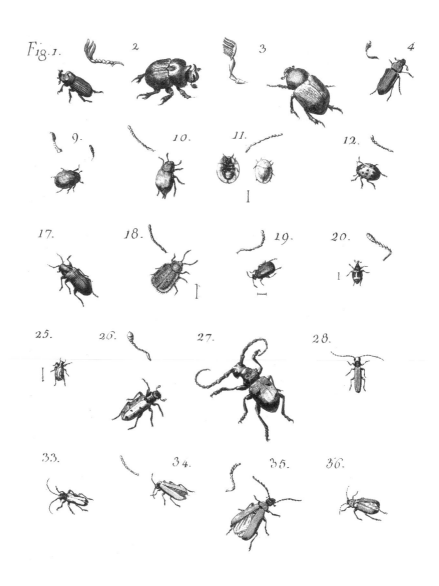

Planche 1 from de Villers' *Caroli Linnæi Entomologia*

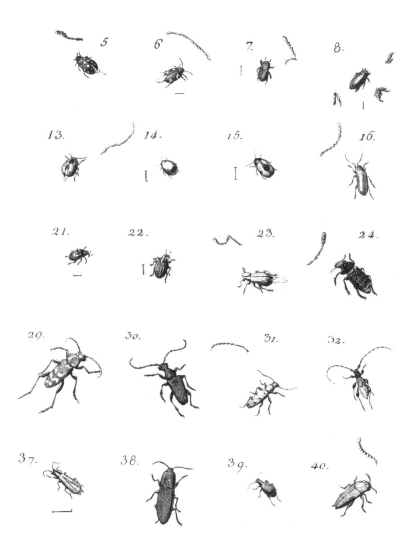

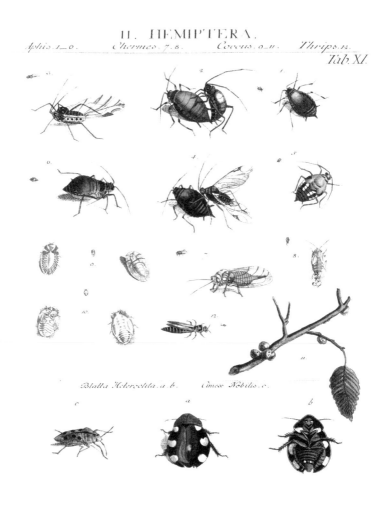

Blatta Heteroclita. a. b. Cimex Nobilis. c.

Tab. **XI** from *Dr. Sulzers Abgekürtze Geschichte der Insecten*

According to Lindroth (1973), two types of entomological systematists followed Linné: polyhistors and specialists. Polyhistors were those who maintained a very broad perspective, working on and describing insects in all orders. Specialists, on the other hand, confined their attention to the insects of single Orders or less inclusive groups. The remaining decades of the eighteenth century belonged to the polyhistors and their publications, many of which were lavish in presentation.

As noted previously, the *Systema naturae*, as important as it was in content, lacked illustrations. Thus, establishing the identity of the Linnaean species was something of a problem. An attempt at alleviation was made by Charles Joseph de Villers who, in 1789, published *Caroli Linnæi Entomologia, fauna suecicae descriptionibus aucta*, an iconography illustrating the species described by Linné. As shown in the accompanying reproduction of a plate, each figure is numbered, and the image of each beetle on the plate is accompanied by a drawing of its antenna, a feature of diagnostic importance in the Linnaean system of classification. The figures are uncoloured and too small to be maximally effective, but along with the correspondingly numbered names on the accompanying pages of plate legends, they are helpful in appreciating the species to which the brief Linnaean descriptions referred.

Published in 1776 (the first year of the American Revolution), *Dr. Sulzers Abgekürtze Geschichte der Insecten, nach dem Linaeischen System* is a treatment in German, following the Linnaean system of classification and naming of the insects known to J.H. Sulzer, a Swiss physician (1735-1813). The work is notable for its finely engraved and hand-coloured illustrations. The accompanying Tab XI shows above the horizontal line various hemipterans (aphids, chermids, scale insects) and a thrips, with numbered life-size and enlarged images. Below the line are lettered images, showing a green stink

Tab. 1 from Römer's *Genera insectorum Linnaei et Fabricii*

bug (family Pentatomidae), and top and bottom views of a rather elegant spotted cockroach. Fig. 4 shows an aphid about to be attacked by a parasitoid wasp, which will sting and, in the process, lay an egg in the aphid. That egg will develop into a wasp larva, which, over a period of days, will consume its aphid host. Following consumption of the host's internal organs, the wasp larva will pupate in the resulting hollowed-out cavity, and ultimately emerge as an adult.

Following on Sulzer's work, another Swiss, J.J. Römer (1763-1819), published *Genera insectorum Linnaei et Fabricii*, a general treatment of insects written in German. The illustrations are its most interesting feature: all are uncoloured copies of the plates published originally by Sulzer some thirteen years previously (bringing to mind that plagiarism was a frequent occurrence preceding universal copyright laws). The plate shown here is a fine uncoloured engraving of scarab beetles, each image about lifesize, the largest being that of the African goliath beetle.

Yet another volume treating all known insect orders to present the Linnaean system of classification, and the Linnaean genera through illustration, was *Les genres des insectes de Linne: constatés par divers échantillons d'insectes d'Angleterre, copiés d'après nature*, by J. Barbut, published in 1781. The text on each page is in two columns: one in English and one in French. The engraved, hand-coloured insect images are in lifelike poses, with members of related groups placed in juxtaposition. Thus, Plate 3 shows various genera of the Order "Hemiptera." These taxa are today recognized as orthopteroids, with *Blatta* (Genus I) and *Mantis* (Genus II) belonging to the Order Dictyoptera, and the members of Genus III (*Grylli*), belonging to the Order Orthoptera.

Moses Harris (circa. 1731-1785), a London engraver and miniature painter, who was most interested in insects, published the

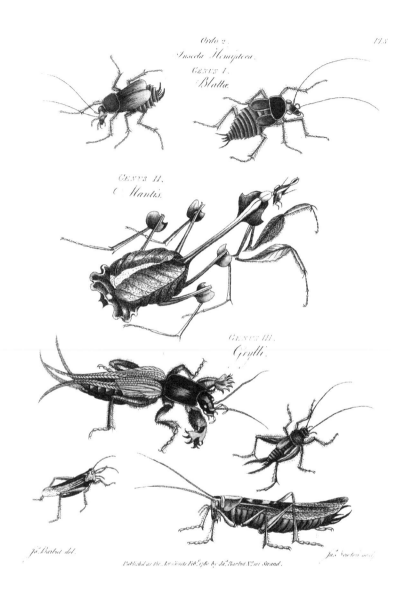

Exposition of English insects in 1782. It was exceptionally thorough, including an excellent discussion of insect structure, and a discussion of colour, with a colour chart. The text is in French and English, containing much new information about British insects. The illustrations (51 engraved plates; 500 hand-coloured figures) are excellent. His Tab. XIV shows five crane fly (family Tipulidae) adults, representing five species, and two larvae (a and b) toward the bottom of the page. At top is a drawing of a wing, with the veins clearly and correctly indicated.

A.M.F.J. Palisot de Beauvois (1752-1820), a French naturalist, part-time civil servant of the French government, and teacher of music and languages (Papavero 1971) published *Insectes recueillis en Afrique et en Amérique, dans les Royaumes d'Oware et de Benin, à Saint Domingue, et dans les États-Unis, pendant les années 1786-1797* in 1805. He presented the publication as an illustrated continuation of the *Natural history* of Buffon. Palisot de Beauvois' sumptuous work, with engraved, hand-coloured plates featuring lifesize images, offered descriptions of the new species encountered by its author during his various stays over a twenty-year period in West Africa, in the West Indian island of Santo Domingo, and in the United States. The illustrations facilitate the identification of the species that he described. Illustrated in the plate reproduced here are spider wasps of the genus *Pepsis*, the females of which parasitize tarantulas.

Beginning in the nineteenth century, the entomological polyhistors were replaced in large measure by specialists. This change was the result of three circumstances. First, thanks to the efforts of the polyhistors, the number of known insect taxa had increased to a point at which most interested individuals did not have the mental capacity to deal effectively with such diversity. Second, with insect material accumulating in the various national European

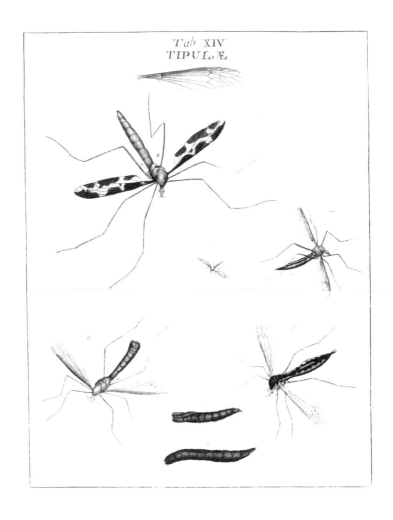

Tab. XIV from Harris' *Exposition of English insects*

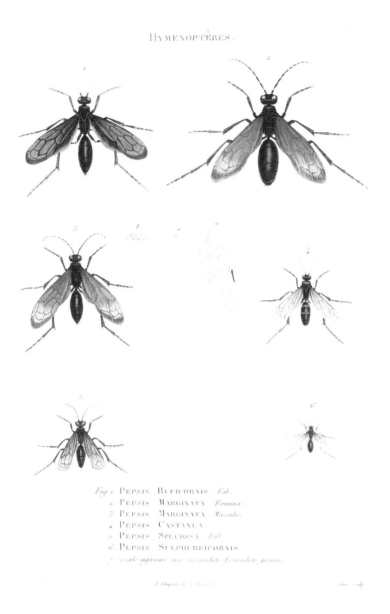

Hyménoptères, Pl. II from Palisot de Beauvois' *Insectes recueillis en Afrique et en Amérique*

1	LEBIA	CALLIPARIS	9	LIA QUADRIANNULATA.	18	AGRA	SEMIFULVA
2	„	HISTRIONICA	10	„ MELANOCREPIS.	19	„	MULTISETOSA
3	„	HISTRIONICA Var C	11	AGRA EURYPELMA.	20	„	ELAINA.
4	„	COPTODERINA	12	„ CASTANEIPES	21	„	FURPUREA
5	„	MESOSTIGMA	13	„ ÆNEOLA	22	„	CHRYSOPTERYX.
6	„	HILARIS	14	„ OBLONGOPUNCTATA	23	„	DIMIDIATA
7	LIA	QUADRINOTATA	15	„ RESPLENDENS	24	„	VIRGATA
8	„	OCELLIGERA	16	„ REGULARIS.	25	PSEUDOMORPHA PILATEI	
			17	„ FADA.			

W Purkiss lith.

Hanhart imp
341

Coleoptera. Vol. I, Pt. I, Tab. 12 from Bates' *Biologia centrali-americana.*
Insecta. Coleoptera

museums as a result of the great journeys of exploration, it was becoming apparent that many more species were in existence than had been believed by previous generations. The sheer volume of species required concentration on, at most, single Orders. Third, systematists tended to work as individuals, rather than engaging in cooperative ventures. With close cooperation of specialists, collective works of considerable taxonomic breadth would have been possible.

The volume of new entomological material forced changes to entomological publications. Where previously, researchers produced detailed, profusely illustrated volumes that treated relatively few species belonging to many different Orders, specialists tended to produce shorter, unillustrated papers, restricted to descriptions of large numbers of closely related species. Although generally true, there were notable exceptions. Perhaps the grandest for the nineteenth century was the *Biologia centrali-americana*.

The publication consists of 215 parts (in 52 volumes, issued 1879-1915) treating most of the Macroanimalia (including insects) of Central America, and five volumes treating the Macroflora. The volumes are quarto size, printed on high-quality paper, and with profuse lithograph illustrations, in colour for those who could afford it. Thanks to the foresight of a librarian, the University of Alberta Library has the complete set of the zoological volumes. At the time of purchase, the botanical volumes were no longer available.

The editors, and those who paid the cost of publication, were two Englishmen of means: Frederick Du Cane Godman (1834-1919), and Osbert Salvin (1835-1898). Interested principally in butterflies and birds, they themselves carried out extensive ornithological exploration in Central America during the 1850s and 1860s, and employed professional collectors to subsequently carry on the work.

1.2. CASTNIA ZAGRÆA. 4 CASTNIA VERAGUANA.
3 ,, DIVA. 5 ,, FUTILIS.

Heterocena, Tab. 4 from Druce's *Biologia centrali-americana. Insecta.*
Lepidoptera-Heterocera

Establishing their own museum in London, Godman and Salvin (no doubt with paid assistants) received, catalogued, and accurately labelled all of the material that was sent to them. In the 1870s they realized the opportunity offered by this grand assemblage of biological material, and determined to undertake a self-financed publication that would allow the characterization of the entire macrobiota for what they could see was an incredibly biologically rich part of the world. Thus was born the idea of the *Biologia centrali-americana*, which was brought to fruition with publication of the first fascicles in 1879.

Godman and Salvin concentrated their personal efforts on the birds, though they did contribute to other groups as well, particularly the butterflies. However, they recognized their limitations, and sought other systematists to deal with the groups with which they were not familiar, or in which they had little personal interest. Thus, the venture became one of cooperation. Through their foresight, enthusiasm, and monetary investment, they succeeded in producing a description and scientific analysis of the biota of a major and evolutionarily important region of the world. It is an unequalled accomplishment.

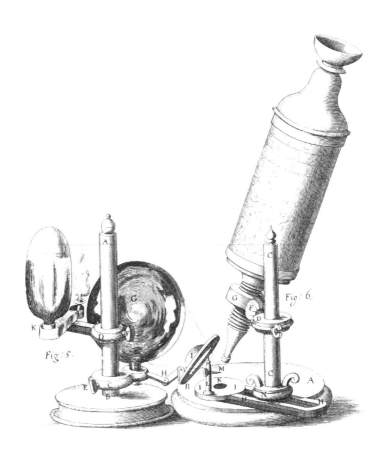

Schem I from Hooke's *Micrographia* (detail)

INSECT MICROSCOPY
AND ANATOMY

Robert Hooke's figure of a compound microscope (*Micrographia*, 1665) gives one a reasonably good idea of what equipment was available when the first detailed examination of an insect was carried out. Such a microscope was initially used to gain an appreciation of the external detail of the body and appendage form of insect specimens so small that these aspects could be seen only dimly with the unaided eye. Researchers with such a goal are referred to here as "microscopists." Somewhat later, the microscope was used to permit discovery and study of the internal organs. This required dissection, and workers who engaged in that activity are referred to as "anatomists," using that word in its literal sense. This distinction is an arbitrary, but convenient, way of grouping individuals who employed similar working methods but with different interests.

THE MICROSCOPISTS

Hooke (1635-1703), the son of a vicar, was not the first to turn a compound microscope on insects, but he was the first to publish a treatise devoted exclusively to microscopical observations. As a student at Oxford, Hooke's knowledge and inventive skill spurred the great pioneering chemist Robert Boyle to engage him as an assistant. Following graduation, he became a professor of

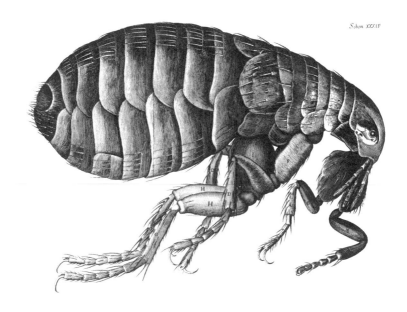

Schem **XXXIV** from Hooke's *Micrographia*

Tav. I from Redi's *Esperienze intorno alla generazione degl'insetti*

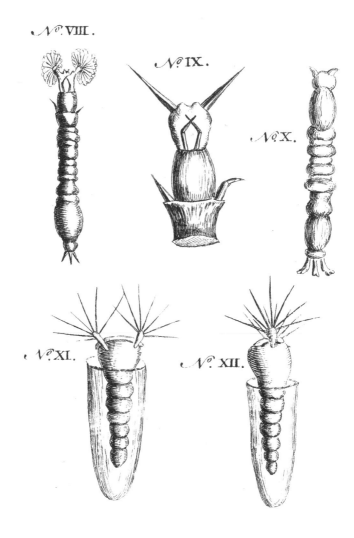

Pl. XIV from Baker's *Employment for the microscope* (detail)

geometry at Gresham College, London. Hooke designed and constructed his own microscope, which he used to examine a wide variety of animals, plant parts, and minerals (Lisney 1960), presenting his observations in the *Micrographia*. The contents are not arranged coherently, with the organization apparently reflecting the author's whim. Nonetheless, the engraved figures attest to an enquiring mind, to the eyes of a disciplined observer, and to the hand of a masterful illustrator. Although he did not exhibit a special interest in insects, Hooke was probably attracted to them because of their small size and structural complexity, and thus suitability for examination with a microscope. He prepared wonderfully detailed images of several insects or parts thereof, including the justly famous figure of a human flea (*Pulex irritans* Linné), that is reproduced here, from a facsimile copy of the *Micrographia*, published in 1987.

The Italian physician, poet, and keen biologist, Francesco Redi (1626-1698) also used his microscope to study and illustrate small parasitic insects. The reproduction of a plate from *Esperienze intorno alla generazione degl'insetti* (1674) shows images of different species of bird lice. The figures illustrate accurately the form of the specimens, but the antennae and terminal appendages of the legs are quite inaccurate, indicating perhaps that Redi's microscope was of lesser quality than the one used by Hooke.

However, the most important part of the book is the description of Redi's careful experimental investigations on the source of insects. Up to the time of Redi's work, the commonly-held belief was that insects were generated spontaneously from decaying organic matter. Redi succeeded in demonstrating that, like vertebrates and indeed all forms of life, insects came from eggs produced by a female of the same species. This disproved the abiogenetic theory, and opened the way to perceive insects as normal animals, and more importantly, to perceive the unity of the living world (Mayr 1982).

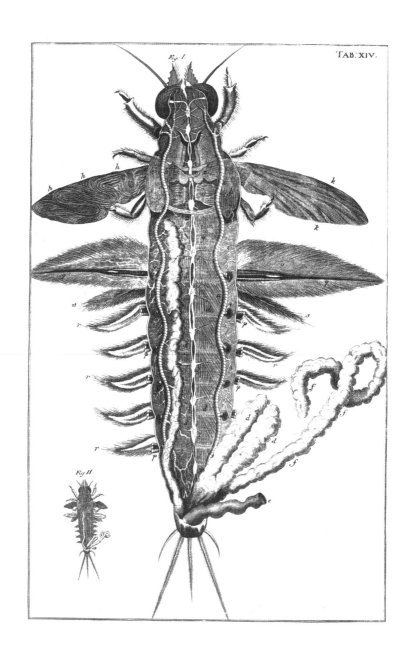

Tab. XIV from Swammerdam's *The book of nature: or, the history of insects*

A rather curious volume is Henry Baker's *Employment for the microscope* (1764), about structure and use of compound microscopes. In addition to providing instruction about these matters, the book contains many illustrations of objects or creatures examined with a microscope. Included therein is a series of images showing part of the life history of a blackfly species (Nos. VIII-X, a larva or parts thereof; Nos. XI and XII, pupae). At the time, the association between the aquatic blackfly larvae and the terrestrial, blood-feeding, pestiferous adults had not been made. Therefore, the figures published by Baker were nameless, and the images were simply presented as representatives of the small inhabitants of the aquatic environment.

THE ANATOMISTS

Jan Swammerdam (1637-1680) was most knowledgeable about the work of the vertebrate anatomists of his time and of the previous century, having graduated in medicine from the University of Leiden, Netherlands, in 1660. He extended this knowledge to discovering and illustrating the internal structural features of insects, as part of a more general program that included intensive life history studies. Swammerdam excelled in dissection of very small creatures. To do so required very fine equipment (including scissors), which he made with the aid of a microscope. The accompanying Tab. XIV shows a much enlarged image (Fig. 1) of a dissected mayfly larva. Beside and to the lower left of the enlargement is an image of about actual size of the specimen. Lower-case letters provide reference points that are referred to in the text. This is Swammerdam's most-cited illustration. It is taken from *The book of nature: or, the history of insects* (1758), which is an English translation of the Dutch and Latin *Bybel der natuure* or

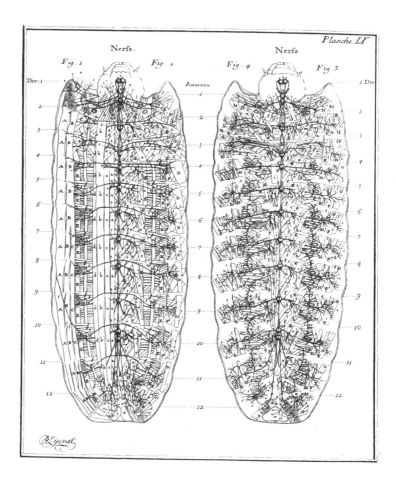

Planche IX from Lyonnet's *Traité anatomique de la chenille*

Biblia naturae (1737-1738). The *Bybel*, in turn, published nearly six decades after Swammerdam's death, was based on his unpublished writings and illustrations. Dance described this publication as "a magnificent folio work in two volumes, which contains perhaps the finest collection of microscopic studies ever produced by a single observer" (1978: 184). According to Beier (1973), Swammerdam placed insect structure on a broad comparative basis, and made important contributions to knowledge of insect development which proved to be of substantial value in establishing a natural insect classification.

Carrying on in the path of close examination and detailed illustration of internal insect structure was a Dutch lawyer, diplomat, and linguist, Pieter Lyonnet (1707-1789), whose passion for exact observation was such that he thought that theory should be banned from science (Tuxen 1973). Lyonnet's great work *Traité anatomique de la chenille qui ronge le bois de saule*, published in 1762, comprises more than 600 pages and 18 plates that he engraved himself. The species (*Cossus ligniperda*) on which this work is based is a moth of the family Cossidae, the larvae of which bore in wood of injured trees. Lyonnet's volume treats only the larva, or caterpillar. He planned to treat the other life stages in similar fashion, but his death unfortunately intervened.

Each plate emphasizes a different organ system. Planche IX shows the nervous system, at two levels. The caterpillar was cut along the midline of the upper surface, and the body then splayed to reveal the internal organs. Most other organ systems were removed, leaving the nervous system (central longitudinal nerve cord and peripheral nerves) and the underlying muscles of the body wall. After the inner nerves and layer of muscles had been identified and illustrated (Figs. 1 and 2), they were removed with the central nerve cord remaining intact. The removal revealed a deeper set of peripheral nerves and muscle layer (Figs. 3 and 4). Labelling on the images is extensive.

Fig. 34,35 Phymata crassipes – Fig. 36-43 Aradus avenius.
44-47 Cimex lectularius – Fig 48-54 Reduvius stridulus

Pl. IV from Dufour's *Recherches anatomiques et physiologiques sur les hémiptères*

The basis for understanding the internal structure of insects was well established near the middle of the eighteenth century by the work of Swammerdam, Lyonnet, and a few other like-minded, talented individuals with a passion for the small creatures that rule the earth. A broad survey of internal organs was yet to be accomplished, in order to discover their range of variation, and to begin the understanding of the significance of such variation. The person who undertook the necessary survey was Léon J.M. Dufour (1780-1865), a retired army surgeon, who had served with distinction in several Napoleonic military campaigns, and subsequently practiced medicine in the Landes district of southwestern France (Locy 1925). An enthusiastic dissector of insects, between 1820 and 1860 Dufour published numerous papers, describing and illustrating the organ structure of many orders and their included families. He wished to formulate a general field of research on insect structure, and did indeed lay the foundation for such (Richards 1973), which is known today as insect morphology. But the maximum extent of that field was not achieved until the twentieth century, with the incorporation of knowledge of embryonic development (embryology), and tissue structure (histology)—disciplines that were not developed during Dufour's time.

An example of Dufour's work is provided by Pl. IV, from *Recherches anatomiques et physiologiques sur les hémiptères* (1833). Illustrated by images on lithographic plates are various structures of representatives of four true bug (Hemiptera) families: Phymatidae, Aradidae, Cimicidae (bedbugs), and Reduviidae. Figs. 34, 44, and 48 show the salivary, digestive, and excretory systems. Note how identical arrangement and orientation of parts facilitates comparisons from one to the other, and how readily differences become apparent, even to an untrained eye.

CONCLUDING REMARKS

Iconography is for biology what mathematical formulae and equations are for the physical sciences—a method of abstracting and summarizing precisely-made observations. But to make the images accessible they must be reproduced, which involves printing. The improvement of printing techniques during the sixteenth to the nineteenth centuries made possible reproduction of the fine details of form and tone that are essential to accurate representation of the images produced by skilled illustrators.

Complementing the development of excellent iconography was microscopy. With a good compound microscope, one could see and illustrate small insects, as well as the intricate inner workings of larger ones. Without microscopes, the reach of entomology would have been limited to what could be observed with the unaided eye.

How did excellent iconography relate to the development of entomology? Demonstrating the wonderful variety in form and colour of the insect world may have induced others to take up study of insects. Certainly, the figures of insects portrayed by gifted illustrators induced wealthy patrons of learning to finance entomological books, which ultimately led to availability to the public of information about insects. More directly, figures of insects published with associated verbal descriptions by one entomologist

could act as the common foundation on which others could begin to construct the body of entomological knowledge.

The first disciplines of entomology to develop were those for which iconography was vital, namely systematics and morphology (the latter with its handmaiden, anatomy). In the fullness of time, systematics led to discovery and classification of nearly a million insect species. Morphology blossomed as the study of structure extended in the latter part of the nineteenth century from the level of organs, to that of tissues making up the organs, to the cells that collectively form the tissues, and to the pathways of development that extend from egg to adult.

Isaac Newton, when asked the source of his genius, replied that if he had seen further than others, it was by standing on the shoulders of giants. This essay has been a celebration of the works of some of the entomological "giants"—those rare individuals with exceptional talent and drive for perfection, whose collective pioneering efforts in the course of three centuries pushed forward the frontiers of learning. They shared an economic status that permitted devoting time to pursuits that were without immediate material benefit, as well as a deep passion for learning about insects. They pursued that passion with unrelenting zeal. Collectively, through their observations, illustrations, and writing, they laid a firm foundation for development of entomology. We may be thankful for their exemplary contributions. *Floreat Entomologia*!

George E. Ball
University of Alberta

WORKS CITED

Max Beier. "The early naturalists and anatomists during the Renaissance and seventeenth century." Smith, Mittler, and Smith 81-93.

S. Peter Dance. *The art of natural history: animal illustrators and their work.* Woodstock, N.Y.: The Overlook Press, 1978.

D. Keith McE. Kevan. "Soil zoology then and now—mostly then." *Quaestiones entomologicae* 21 (1985): 371.7-472.

David M. Knight. *Zoological illustration: an essay towards a history of printed zoological pictures.* Dawson: Archon Books, 1977.

W.E. Leach. "History of Entomology." *The Edinburgh encyclopaedia.* ed. D. Brewster. Edinburgh: J. Murray, 1830.

Carl H. Lindroth. "Systematics specializes between Fabricius and Darwin: 1800-1859." Smith, Mittler, and Smith 119-154.

Arthur A. Lisney. *A bibliography of British lepidoptera, 1608-1799.* London: The Chiswick Press, 1960.

William A. Locy. *The growth of biology.* New York: Holt, 1925.

Ernst Mayr. *The growth of biological thought.* Cambridge, Massachusetts ; London: The Belknap Press of Harvard University Press, 1982.

G. Morge. "Entomology in the western world in antiquity and in medieval times." Smith, Mittler, and Smith 37-80.

Nelson Papavero. *Essays on the history of neotropical dipterology, with special reference to collectors (1750-1905).* Vol. I. São Paulo: Museu de Zoologia, Universidade de São Paulo, 1971.

A. Glenn Richards. "Anatomy and morphology." Smith, Mittler, and Smith 185-202.

Ray F. Smith, Thomas E. Mittler, and Carroll N. Smith (eds). *History of entomology.* Palo Alto, Calif.: Annual Reviews Inc., 1973.

Gordon Rattray Taylor. *Science of life: a picture history of biology.* New York ; Toronto: McGraw-Hill Book Co. Inc., 1963.

Soren Ludwig Tuxen. "Entomology Systematizes and Describes, 1700-1815." Smith, Mittler, and Smith 95-118.

WORKS EXHIBITED

Eleazar Albin. *A natural history of English insects. Illustrated with a hundred copper plates, curiously engraven from the life, and (for those who desire it) exactly coloured by the author Eleazar Albin, painter; to which are added, large notes, and many curious observations, by W. Derham* London: Printed by William and John Innys ..., 1724.

Ulisse Aldrovandi. *De animalibus insectis libri septem: cum singulorum iconibus ad viuum expressis.* Bologna: apud Ioan. Bapt. Bellagambam, cum consensu superiorum, 1602.

Henry Baker. *Employment for the microscope: in two parts. I. An examination of salts and saline substances ... II. An account of various animalcules never before described* 2nd ed. London: Printed for R. and J. Dodsley ..., 1764.

James Barbut. *Les genres des insectes de Linne: constatés par divers échantillons d'insectes d'Angleterre, copiés d'après nature.* Londres: Imprimérie, par J. Dixwell et se vend au progit de l'auteur chez J. Sewell, 1781.

Henry Walter Bates. *Biologia centrali-americana. Insecta. Coleoptera.* [eds. Frederick Du Cane Godman and Osbert Salvin]. 7 vols. London: Printed by Taylor and Francis, 1879-1911.

John Blackwall. *A history of the spiders of Great Britain and Ireland.* 2 vols. London: Published for the Ray Society by Robert Hardwicke ..., 1861-1864.

Carl Alexander Clerck. *Svenska spindlar uti sina hufvud-slägter indelte samt under några och sextio särskildte arter beskrefne och med illuminerade figurer uplyste, på Kongl. vetensk. societ. i Upsala befallning utgifne af dess ledamot Carl Clerck. Aranei svecici, descriptionibus et figuris aeneis illustrati, ad genera subalterna redacti, speciebus ultra* LX *determinati, auspiciis Regiae societatis scientiarum upsaliensis.* Stockholmiae: literis L. Salvii, 1757.

Georges Cuvier. *Le Règne animal distribué d'après son organisation: pour servir de base à l'histoire naturelle des animaux et d'introduction à l'anatomie comparée. Édition accompagnée de planches gravées, représentant les types de tous les genres, les caractères distinctifs des divers groupes et les modifications de structure sur lesquelles repose cette classification. Par une réunion de disciples de Cuvier, MM. Audouin, Blanchard, Deshayes, Alcide d'Orbigny, Doyère, Dugès, Duvernoy, Laurillard, Milne Edwards, Roulin et Valenciennes.* 11 vols. Paris: Fortin, Masson et cie, [1836-1849].

Herbert Druce. *Biologia centrali-americana. Insecta. Lepidoptera-Heterocera.* [eds. Frederick Du Cane Godman and Osbert Salvin]. 4 vols. [London: Printed by Taylor and Francis, 1881-1915].

Léon Dufour. *Recherches anatomiques et physiologiques sur les hémiptères, accompagnées de considérations relatives à l'histoire naturelle et à la classification de ces insects.* Paris: Bachelier, 1833.

Frederick Du Cane Godman and Osbert Salvin. *Biologia centrali-americana. Insecta. Lepidoptera-Rhopalocera.* 3 vols. [London: Printed by Taylor and Francis], 1879-1901.

Moses Harris. *Exposition of English insects; including the several classes of Neuroptera, Hymenoptera, & Diptera or Bees, flies & Libellula.* [London]: White, 1782.

Robert Hooke. *Micrographia: or some physiological descriptions of minute bodies made by magnifying glasses with observations and inquiries there upon.* Facsimile ed. Lincolnwood, Ill.: Science Heritage, 1987.

Jacob Hübner. *Sammlung exotischer Schmetterlinge.* Augsburg, Im Verlag der Hübnerschen Werke, bey C. Geyer. 5 vols. Nouvelle edition fac-simile française dirigée par P. Wytsman avec notes additionelles par W.F. Kirby. Bruxelles: V. Verteneuil & L. Desmet, 1894-1912.

Karl Gustav Jablonsky. *Natursystem aller Bekannten in- und ausländischen Insekten, als eine Fortsetzung der von Büffonschen Naturgeschichte: Nach dem System des Ritters Carl von Linné bearbeitet von Carl Gustav Jablonsky* 6 vols. Berlin: J. Pauli, 1785-.

Joannes Jonstonus. *Historiae naturalis de insectis libri III: de serpentibus et draconib libri II, cum aeneis figuris.* Francofurti ad Moenum: Impensis haeredum Merianoru, 1653.

Carl von Linné. *Systema naturae.* Facsimile of the first volume of the tenth edition (1758). London: Printed by Order of the Trustees, British Museum (Natural History), 1956.

Pieter Lyonnet. *Traité anatomique de la chenille, qui ronge le bois de saule: augmenté d'une explication abrégée des planches, et d'une description de l'instrument et des outils dont l'auteur s'est servi... .* La Haye: Se vend chez Pierre Gosse Jr. and Daniel Pinet ... ; Amsterdam: Marc Michel Rey ..., 1762.

Maria Sibylla Merian. *Butterflies, beetles and other insects: the Leningrad book of notes and studies.* Ed. by Wolf-Dietrich Beer. 2 vols. Copy no. 89 of a limited ed. of 1800. [New York]: McGraw-Hill International Book Company, 1976.

Thomas Moffett. *Insectorum sive minimorum animalium theatrum: olim ab Edoardo Wottono, Conrado Gesnero, Thomaque Pennio inchoatum: tandem Tho. Movfeti Londinâtis opêra sumptibus'q; maximis concinnatum, auctum, perfectum: et ad vivum expressis iconibus suprà quingentis illustratum.* Londini: T. Cotes, 1634.

Antoine Guillaume Olivier. *Entomologie; ou, Histoire naturelle des insectes, avec leur caractères génériques et spécifiques, leur description, leur synonymie, et leur figure enluminée.* 6 vols. Paris: Baudouin ; Lanneau ..., 1789-1808.

Ortus sanitatis: De herbis et plantis, de animalibus et reptilibus, de avibus et volatilibus, de piscibus et natatilibus, de lapidibus et in terre venis nascentibus, de urinis et earum speciebus, tabula medicinalis cum directorio generali per onmes tractatus. [Strassburg: Reinhard Beck], 1517.

Ambrose Marie François Joseph Palisot de Beauvois. *Insectes recueillis en Afrique et en Amérique, dans les royaumes d'Oware et de Benin, à Saint-Domingue et dans les États-Unis, pendant les années 1786-1797.* Paris: Impr. de Fain, 1805.

Georg Wolfgang Franz Panzer. *Faunae insectorum germanicae initia. Deutschlands Insecten.* Nürnberg: Felsecker, [1793-].

René-Antoine Ferchault de Réaumur. *Mémoires pour servir à l'histoire des insectes.* 7 vols. Paris: De l'Imprimerie royale, 1734-1929.

Francesco Redi. *Esperienze intorno alla generazione degl'insetti fatte da Francesco Redi, Accademico della Crusca, e da lui scritte in una lettera all'illvstrissimo Signor Carlo Dati.* Firenze: Stamperia de P. Matini, 1674.

60

J.J. Römer. *Genera insectorum Linnaei et Fabricii iconibus illustrata.* Vitoduri Helvetorum: prostat apud Henrjc. Steiner et socios, 1789.

August Johann Rösel von Rosenhof. *De natuurlyke historie der insecten: voorzien met naar 't leven getekende en gekoleurde plaate. Volgens eigen ondervinding beschreeven, door den heer August Johan Rösel, van Rosenhof, miniatuur-schilder ; met zeer nutte en fraaie aanmerkingen verrykt, door den heer C.F.C. Kleemann* 4 vols. Te Haarlem ; Amsterdam: C.H. Bohn and H. de Wit, boekverkoopers, [1764-1768].

Adalbert Seitz. *The macrolepidoptera of the world; a systematic account of all the known Macrolepidoptera.* Translated by K. Jordan. 16 vols. Stuttgart: A. Kernen, 1906-1933.

J.H. Sulzer. *Dr. Sulzers Abgekürtze Geschichte der Insecten nach dem Linaeischen System.* 2 vols. Winterthur: Bey H. Steiner ..., 1776.

Jan Swammerdam. *The book of nature: or, the history of insects: reduced to distinct classes, confirmed by particular instances, displayed in the anatomical analysis of many species, and illustrated with copper-plates ... With the life of the author, by Herman Boerhaave. Translated from the Dutch and Latin original edition, by Thomas Flloyed.* 2 vols. London: C.G. Seyffert, 1758.

Edward Topsell. *The history of four-footed beasts and serpents: describing at large their true and lively figure, their several names, conditions, kinds, virtues (both natural and medicinal) countries of their breed, their love and hatred to mankind, and the wonderful work of God in their creation, preservation, and destruction. ... Collected out of the writings of Conradus Gesner and other authors ... Whereunto is now*

added, The theater of insects, or lesser living creatures: as bees, flies, caterpillars, spiders, worms &c. A most elaborate work : by T. Muffet, Dr. of Physick. ... with the addition of two useful physical tables, by J.R.... 2 vols. London: Printed by E. Cotes for G. Sawbridge, 1658.

Charles Joseph de Villers. *Caroli Linnæi Entomologia, faunae suecicae descriptionibus aucta; D. D. Scopoli, Geoffrey, de Geer, Fabricii, Schrank, &c. speciebus vel in systemate non enumeratis, vel nuperrime detectis, vel speciebus Galliae Australis locupletata, generum specierumque rariorum iconibus ornata; curante & augente Carolo de Villers.* 4 vols. with 1 vol. of plates. Lugduni: Piestre et Delamolliere, 1789.

ACKNOWLEDGEMENTS

I was pleased and honoured to have been invited to participate in the exhibition, planned by Jeannine Green (Special Collections Librarian) and Merrill Distad (Associate Director of Libraries), featuring the older, classical entomological literature in the University of Alberta Library. This participation provided the opportunity to make use of the excellent space and facilities of the Bruce Peel Special Collections Library, and to become acquainted with the friendly, well-informed, enthusiastic, and helpful staff. I am grateful to Allison Sivak, who patiently and cheerfully reviewed several drafts of the manuscript that preceded this catalogue. Her helpful comments were of substantial value in preparing the final version, but the author remains solely responsible for any errors of omission or commission. As well, Ms Sivak prepared the bibliography that graces this volume. Jeannine Green offered general advice and encouragement, and was most considerate and commendably patient as several deadlines came and went, with little visible sign of progress on the author's part. Carol Irwin prepared the actual exhibition of the entomological volumes. I extend my thanks also to Jeff Papineau at the Special Collections Library.

I thank the designer of the project, Marvin Harder, who not only prepared the text and illustrations for printing, but helped in choosing the illustrations that were included. Linda Distad is to be commended for her careful eye in proofreading the final catalogue draft.

Pamela M. Henson (Historian, Smithsonian Institution Archives, Washington, D.C.) obligingly drew to my attention several important and useful references that served as my introduction to the literature about natural history illustration.

Several of my entomological colleagues in the Department of Biological Sciences assisted in various ways: Danny Shpeley (Collections Manager, Strickland Entomological Museum) loaned the boxes of specimens that grace the central display case; Douglas A. Craig loaned the old microscopes, also in the central display case; Bruce S. Heming offered help with historical questions, as requested, and provided general encouragement; and Andrew P. Nimmo loaned me an essay about entomological illustration that he had written as an undergraduate student, which proved to be enlightening and a worthy starting point for my own endeavours. Robin E. Leech assisted by obtaining information about the life and arachnological work of Carl A. Clerck, during the eighteenth century.

Finally, I thank Ronald B. Madge, my friend of nearly half a century, for making this exhibition possible both through his interest in entomological literature, and through his generous donations to the University of Alberta Library.

64

Printed in 11.5 point Jenson
on
100 lb. Mohawk Superfine Eggshell Cover
and
100 lb. Mohawk Superfine Smooth Text
by
McCallum Printing Group Inc.
Edmonton, Alberta